EDWARD HOPPER

LIGHT YEARS

Essay by Peter Schjeldahl

October 1 to November 12, 1988

Hirschl & Adler Galleries, Inc.
21 East 70th Street New York, NY 10021

COVER: 13. *Captain Upton's House* (detail)

©1988 Hirschl & Adler Galleries, Inc.
Library of Congress Catalog Number:
88-82522
ISBN: 0-915057-23-9

ACKNOWLEDGMENTS

This exhibition would not have been possible without the generous assistance and cooperation of a number of individuals and their corresponding institutions. First and foremost, we would like to thank J. Anton and Laurence C. Schiffenhaus, whose mother, Mary R. Schiffenhaus, was a close friend of Jo Hopper's. The collection of drawings bequeathed to Mrs. Schiffenhaus by Jo Hopper formed the basis of this exhibition. Other important contributors include ACA Galleries, New York; Dominique H. Vasseur and Jean A. Mazzarella, The Dayton Art Institute, Ohio; Mr. and Mrs. Daniel W. Dietrich II; Mrs. Daniel Fraad; Mr. and Mrs. George Greenspan; Mr. and Mrs. Joel W. Harnett; John Leeper, Jean Williams, and Bann Williams, Marion Koogler McNay Art Museum, San Antonio, Texas; William Rubin, Cora Rosevear, and Thomas D. Grischkowsky, The Museum of Modern Art, New York; Charles Eldredge, Elizabeth Broun, and Margaret G. Harman, National Museum of American Art, Smithsonian Institution, Washington, D.C.; Robert D. Schonfeld, The Shearson Lehman Hutton Collection; Mr. and Mrs. Mortimer Spiller; Kathryn and Robert Steinberg; Jan E. Adlmann and Rebecca E. Lawton, Vassar College Art Gallery, Poughkeepsie, New York; Deborah Lyons, Anita Duquette, and Roberta Lemay, Whitney Museum of American Art, New York; and several private collectors who elected to remain anonymous. To each of them, we extend our deepest thanks.

Peter Schjeldahl has provided us with an insightful and enjoyable essay, which offers a fresh look at Hopper's work. Many thanks to him for his enlightening words.

The continuing support of the Hirschl & Adler staff has, as always, been invaluable. In particular we would like to thank Sandra K. Feldman, Monica Moran, Vance Thompson, and Heatherly Vermillion for their help with the project.

Susan E. Menconi
James L. Reinish
Meredith E. Ward

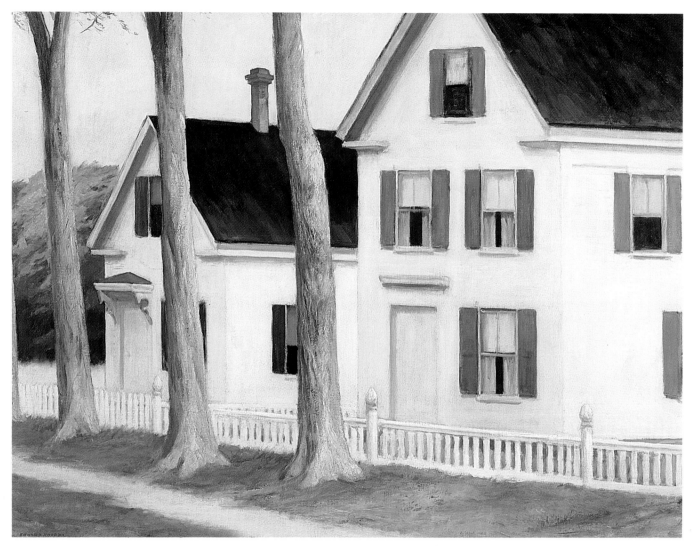

56. *Two Puritans*

4

HOPPERESQUE

By Peter Schjeldahl

EDWARD HOPPER had first-rate artistic skills which in his mature work, after 1924 or so, he seemed to regard with familiar contempt. In his best pictures—each one-of-a-kind and started from scratch, as if it were the first painting in the world—he regularly pushed his talents to the breaking point. You can sense their creaks and groans in Hopper's often tortured surfaces and "awkward" figures, at the same time that you feel the force of driven genius that made him the best American artist to emerge after Homer and Eakins and before the Abstract Expressionists: better than Hartley, Marin, and Davis, though not as compelling in pictorial invention, and better than Demuth, Dove, and O'Keeffe, though not nearly as refined. Hopper was better because his ambition for art was larger—too large to permit him a moment of feeling successful—and because he submitted himself to it with a passion rivaled only in Hartley's most eloquent late paintings. His contemporaries pursued the necessary task of getting the United States up to speed with European modernism. Hopper's job was the self-assigned, quite uncalled-for, awesome one of combining formal rudiments of Post-Impressionism with a meager American store of pictorial authenticities—from Eakins and Homer, from unnoticed aesthetics of demotic architecture and popular culture, from folk art and commercial illustration—to tell the truth and, if not the whole truth, nothing but the truth about the human soul in a hard country.

The next time you are in any museum's rooms of American "early modernism," perform this test: run your eyes passively along the walls. When you're jarred, like a car hitting a rock in the road, stop. Nearly always, you will be gazing at a Hopper. The reason won't be the picture's subject matter—if you've done the test fairly, you won't be aware of subjects—but the way it's put together, and how the construction grips you. A Hopper has no style, properly speaking, unless sheer effort, straining against the limits of technique, can be called a style. Each element feels *ad hoc*, an emergency measure. The emergency is a moment in narrative time, the breathless midpoint of an unknown story. There are oddly angled, vertiginous spaces and dramatic light, and color that sneaks up on you; but time is the key. The length of your contemplation—literally, how long you pay attention—is time spent outside yourself, in the suspended moment of the scene. (How does Hopper do it? We'll get to that.) You rarely feel that something objectively in the world, some actual place or person or event, is being represented. Simply, you are not given the leisure to wonder about the subject, because you are plunged directly into an apprehension of its meaning. Hopper is more a naturalist than a realist, and a symbolist above all.

Hopper's non-realism is clinched by looking at sketches and studies for his paintings. These are the work not of an observer of the visible world but of an imagination-powered *metteur en scène*, a stage or film director blocking in the vision of a final effect to be reached through cunning labor. Each drawing considers one or more of the decisions that will accumulate to dictate the picture. Even the simple selection of format makes meaning. I find something ineffably racy about the rectangle Hopper draws to start a sketch. It is like a blank movie screen when I'm in the mood for a movie: a silver terrain teeming with memory and anticipation, rife with spiritual possibility. Hopper understood the metaphysic of film like no other artist until, perhaps, Andy Warhol, and better than all but the greatest filmmakers. He had an instinct for the definitive, unarguable, mythic construction of great film images, all the more potent when their subjects are humble and "typical." He understood that afternoon or early morning in a successful picture must evoke *every* afternoon or *all* early mornings, just as each featured man must be Man and each woman Woman. You can see it coming together—and being concentrated, edited down to irreducibles—in the drawing: set-making, lighting, casting.

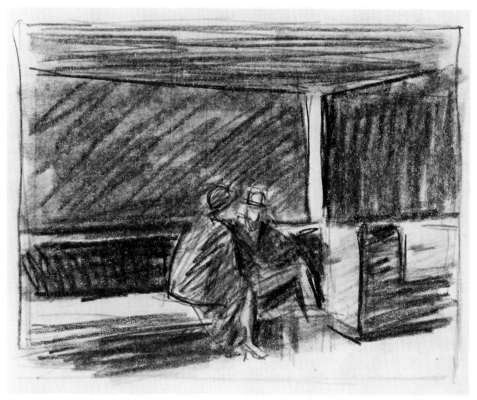

96. *Couple Seated in an Interior*

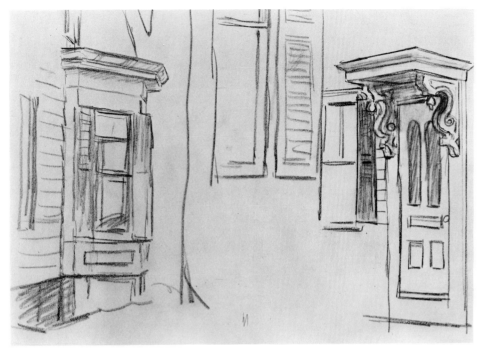

The figure study for *Cape Cod Morning* (illus. p. 55) is a superlative drawing, mightily architectonic and sculptural (it seems to me a waste that Hopper didn't make sculpture). Though covered by a skirt, the woman's legs palpably rise like a solid column to the pelvis, which hinges sharply forward. The torso falls heavily, caught and supported on powerful arms. Note the detail drawings of the hands, subtly distorted to suggest strong pressure. The head and neck strain away from the body, as if to pull free of it. In the painting, the masterful finesse of a draftsmanly conception is literally covered up with paint. (The mature Hopper ruthlessly expunges any "admirable" passage; he forbids us to admire him.) In swift, lovely studies of the bay-windowed house, meanwhile, we see to-be-abolished architectural detail and, on one sheet, a change in the picture's rectangular proportions that reorients it from squarish to horizontal. Brought together on the canvas, raked at a slight forward angle from the right by pale morning sun, the staring woman and the house generate a lateral thrust like that of a ship plowing into swells. "Yearning," the automatic word for the mood suggested, is pathetically inadequate to the frozen violence of the scene, which tells us that whatever we think we know of disconsolateness and desire isn't even the half of it.

Hopper's paintings (portraits, in a real sense) of buildings are his most conventional-seeming, most nearly realist works, making especially instructive their Hopperesque qualities, the narrow margin by which they transcend visual description for psychological symbolism. As

always, it is an affair of *decisions*, strange emphases and abnegations, too pronounced for either realist comfort or aesthetic savor. Some of the decisions may be unconscious. A psychoanalyst might adduce a neurotic pattern from the unenterableness of most Hopper buildings: we rarely see a door clearly, and when we do it rarely looks operable, let alone inviting. All the life of the buildings is in their glaring windows. However, such a lot of life is there, such a visionary intensity (an intensity *of* vision, of purely *seeing*), that any glib analysis is confounded. Whatever may have been stymied in Hopper's psyche did not fail or fester, but simply went elsewhere with the ornery vitality of a tree growing sideways to come up around a boulder. Any sense of isolation in Hopper is always defiantly upbeat: not loneliness, solitude. Regard deserted, apparently forlorn *Gloucester Street* (illus. p. 18). See how the windows of the banal houses *look* in more ways than one, so many rectangular eyes. The doors of the houses may be impassable, but you just know somebody's home. And note the fiercely red, priapic chimneys: there is heat in the cellars equal to a new Ice Age. Waste no pity on those houses.

Waste no pity, either, on any of Hopper's figures, whose meaning is too often marred by sentimental, patronizing interpretations. They are heroes and heroines of American survival, every one of them unkillably resilient. What they are up against in their lives could make you cry, but only imagine yourself in their places. They are dry-eyed and doing fine. Like Hopper's houses, his people are invariably caught in the act of *seeing*. They look outward, like the Cape Cod woman, or abstractedly gaze inward upon thoughts no less real for being invisible to us. In the latter cases, Hopper always provides ambient clues to the character of the person and to the occasion and nature of his or her thoughts. In my own favorite Hopper painting, *New York Movie* (illus. p. 9), an orchestration of ferociously sensual effects pivots in the reverie of the tired usherette. (She overwhelms me: sister, daughter, lover, victim, goddess, all in one, caught in the movie palace that is a modern philosophical realization of Plato's Cave.) You attain Hopper's wavelength when you register how the subjectivity of his places and people is subsumed to the whole picture. A Hopper painting is a window turned inside-out. You don't look into it. It looks out at you, a cyclopic glance that rivets and penetrates. To see and to be seen are the terms of the deal Hopper strikes with us. It is a spirit-enhancing bargain in which some gaucherie, some forced quality of form or execution, is about as onerous as a crooked halo on an angel who has appeared to us, offering to share state secrets of Heaven.

Hopper's crooked halo—formal abruptness, technical rawness—is basic to his profound modernity: not as a self-conscious reflection on the medium (modernist) and still less as an expressive mannerism ("modernistic"), but as an objective correlative of what *lived* modern experience is like. Fragmentary, distracted, moment-to-moment, phenomenological, existential, empirical: no useful term for the character of modern life is not also a straightforward characterization of Hopper's paintings. It has taken American art culture, transfixed by

superficial distinctions of style, a long time fully to catch up to Hopper's advanced truth, his news that stays news. (Like "Kafkaesque," "Hopperesque" names not a style but a particular face of reality—which we would feel even if Hopper never lived, though more obscurely.) Along with Manet, Munch, and other past masters whose "heroism of modern life" (in Baudelaire's clairvoyant phrase) had been depreciated by blinkered attention to *signs* of the modern (modernist, modernistic), Hopper has gained a freshly honed edge from the sensibility of the 1980s. Hopper's keynote—images of life presented with tough-minded candor about the artificial, theatrical nature of images—is also that of some of our most impressive contemporaries, notably Eric Fischl and Cindy Sherman. Like him, they obtrude technique as a democratic site of complicity with the viewer, of dead-level, intimate communication in which aesthetic value must play a subordinate (though scarcely negligible) role.

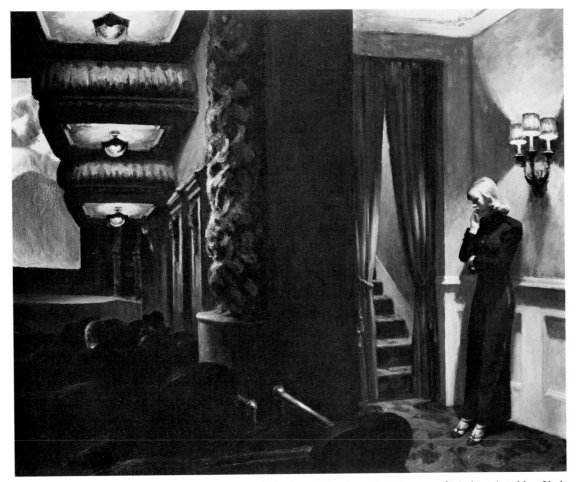

New York Movie (1939) Oil on canvas, 32¼ x 40 1/8 inches. Collection, The Museum of Modern Art, New York. Given anonymously (not in exh.)

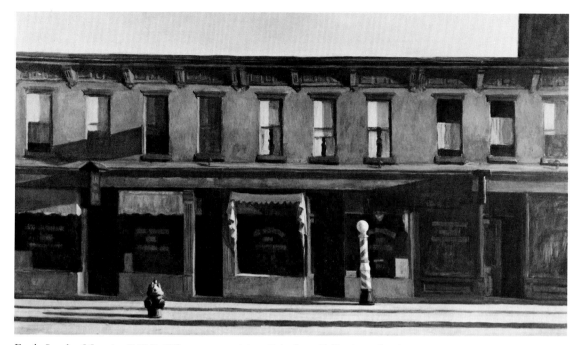

Early Sunday Morning (1930) Oil on canvas, 35 x 60 inches. Collection of Whitney Museum of American Art. Purchase, with funds from Gertrude Vanderbilt Whitney. 31.426 (not in exh.)

Tellingly, few of us could say of a Hopper painting that it is "beautiful" without feeling that we had said, thereby, both too much and too little. A supreme masterpiece like the Whitney Museum's *Early Sunday Morning* (illus. p. 10), with its light-transfigured row of dumpy storefronts, may ravish us, but not in a way apt to remind us of Raphael. A poignance of imperfection unites the painting with its subject, producing a naked factuality as lethal to idealism as DDT is to gnats. Nor is a sentimental formula like "beauty in the ordinary" called for. What Hopper does in paintings of the mundane is far more devastating: he annihilates "the ordinary" along with "the beautiful" and every other conceivable category of aesthetic experience. The effect is "stiking," keeping in mind that so is being hit by a truck. I think the effect is this: the arousal of more emotion than can be explained or contained by its evident cause. It is a lonely sensation, a congestion of feeling incapable of articulation, like being tongue-tied with love. The parallel is pretty close: the aspect of the buildings in *Early Sunday Morning* is like that of an unremarkable person with whom you are suddenly, hopelessly enamored. You can no more describe the aspect than you can breathe under water. You may feel terror unless the person breaks your isolation by speaking to you, if only with a look—as Hopper does with his plainspoken brushwork, literally showing his hand.

The Hopperesque pertains to a glimpse that burns into memory like a branding iron. Anyone who has done much living knows situations in which mood and moment produce a spark, and some utterly neutral thing is permanently charged. I remember being emotionally distressed once in a restaurant in a country town. A distant window in the shadowy room framed an aspen tree against summer sky. I will never forget it. More to the point, I knew immediately, in that instant, that I would never forget the look of that tree, which seemed to me sacred. (I've since forgotten exactly what I was upset about.) I try, and fail, to fantasize how Hopper might have rendered this experience of mine, and my failure instructs me. To lose one's soul to a vision is just a neurological glitch in terms of giving one anything to communicate: it might make a needle jump on some brain-monitoring device. To reel one's soul back in with the vision attached, preserving both in a formal order, is genius. It is what W.B. Yeats called poetry: "a raid on the inarticulate." It is also hard, complicated, equivocal work with a frequent air of rough, even shocking presumption, as Hopper never took pains to conceal.

What is most equivocal in Hopper's practice—shady and potentially embarrassing, an open secret that critics tend to mention, if at all, evasively—is the kinship of such psychological vision to voyeurism: you can get a quick, cheap equivalent—an automatic "burning glimpse"—by peeping at someone who is oblivious of you. (If properly brought up, you will also feel sick; but that's your business.) Hopper plainly was comfortable with the voyeurist impulse, which informs so much of his art directly and just about all of it indirectly—along a Platonic sliding scale from the grossest to the most transcendent knowledge, from the intrusive glance of *Night Windows* to the metaphysical mystery of *Sun in an Empty Room* (*cf.* illus. p. 58). (No one has ever seen, with their own eyes, the inside of an empty room.) Genius may rely as much on a lack of something normal as on possession of something exceptional: in Hopper's case, a lack of shame. Though distinctly puritan in his detachment, his proud spiritual isolation, he wasn't at all inhibited about his sexual interest, notoriously explicit in his characteristic exaggerations of the female body. Only squeamishness, I think, might make us see those distortions differently than the distortions Hopper visits on trees, lighthouses, gas stations, and everything else he responds to. I submit that a polymorphous sexual alertness—"adhesiveness," in Walt Whitman's wonderful term—informed Hopper's perception of the whole world. In the lowest is the highest. A mystic is a voyeur who peeps at God.

Tension between voyeurism and detachment, an aroused fascination and a reticent distance, is the moral engine of Hopper's mature art, giving rise at times to an almost Buddhistic, compassionate equilibrium. He is excited by the unguarded moment, the exposed innocence, of a person, a building, a place—anything at all, though certain things and situations (generally involving windows) pique him more than others. At the same time, he is devoted to the inviolability of the innocence he avidly surveys. You may feel in his work the tug of sex, and

often a tug toward satire, but they are always checked. (That's my ideal of morality, founded not in repression and shame but in respect—the function of self-respect that we call character.) The "coming egghead," as Hopper wryly termed the primly seated, incongruously muscular woman in the late painting *Intermission*, need fear no humiliation from the gazing artist, who claims, however, a corresponding liberty to gaze without qualm. We know such gazes from the work of Hopper's French heroes: the meltingly sensual gaze of Manet, the urbanely cool one of Degas. It is the way civilized eyes behave in the modern city. To have transposed this protocol of gazing from molten Paris to stony America was not the least of Hopper's feats.

If, as I've said, Hopper has won special, heightened appreciation in the 1980s, that does not mean that he has been fully and finally understood. On the contrary, we have become wise precisely to the limitation, the premature closure, of all previous interpretations of his achievement. Our uncertainty was usefully complicated, perhaps, by the rather grueling retrospective that opened in 1980 at the Whitney. That show flooded us with unfamiliar early and otherwise minor pictures, many excellent in their way and valuable for, among other things, showing the virtuosity that Hopper's strongest work suppresses. We learned that Hopper was artistically equipped to develop in any number of ways other than the way he did, which thus took on more dramatic definition as a conscious, even arbitrary quest—an *action* of the spirit with historic and moral resonance. The task now is to winnow from the lovely chaff of Hoppers the obdurate kernel of the Hopperesque, the narrow canon of his works primary to an American intuition of modernity. It is not a task reserved for specialists, though they will play their roles in it. Only individual human hearts can ultimately assess the diagnoses of this doctor of democracy, who asked if the soul—and art, which is its mirror—could survive an inclement century. His answer: yes, *in a way*. I have given my views about the nature and meaning of that way, on the occasion of a discriminating show in which minor work combines with major to explore the threshold of the Hopperesque. I am pleased to believe that, in this matter, there can be no end of views while there are viewers with courage to think and feel.

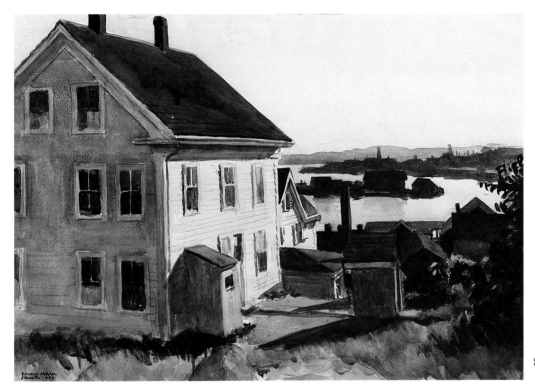

8. *House and Harbor,*
Gloucester

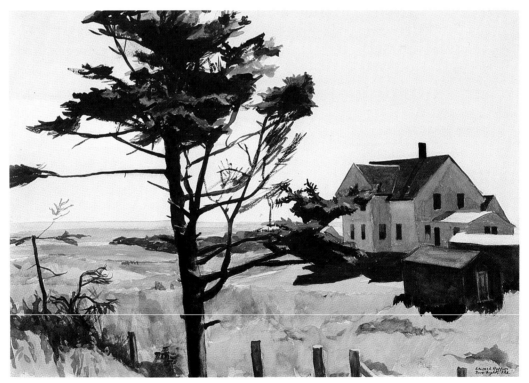

14. *Bill Latham's*
House, Two Lights

13

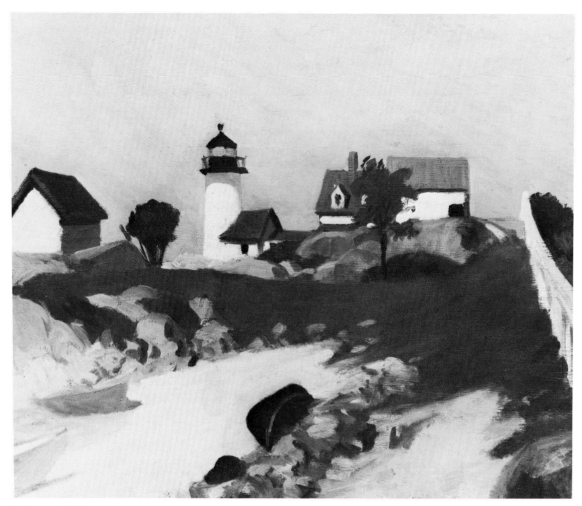

1. *Squam Light*

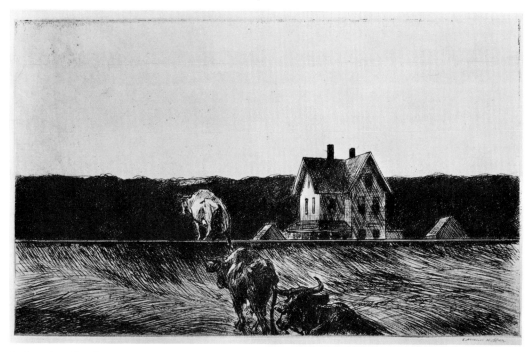

2. *American Landscape*

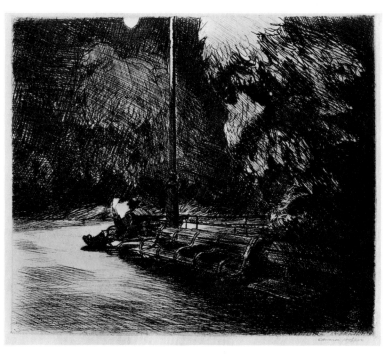

3. *Night in the Park*

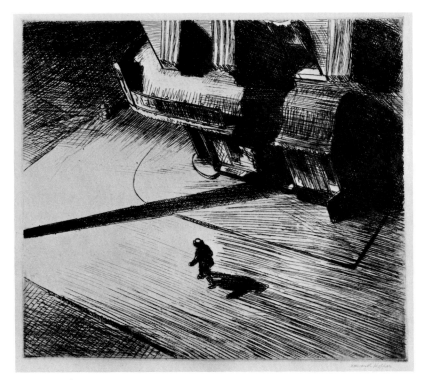

4. *Night Shadows*

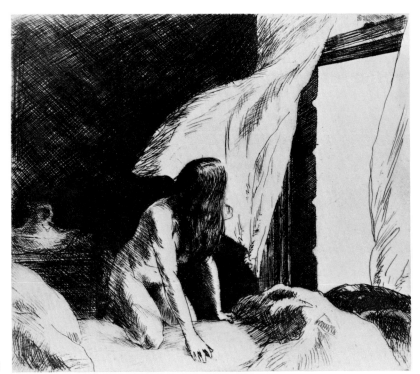

5. *Evening Wind*

16

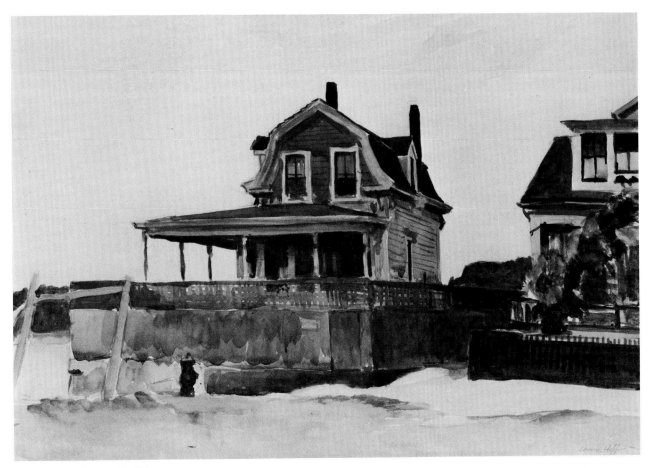

6. *Houses on the Beach, Gloucester*

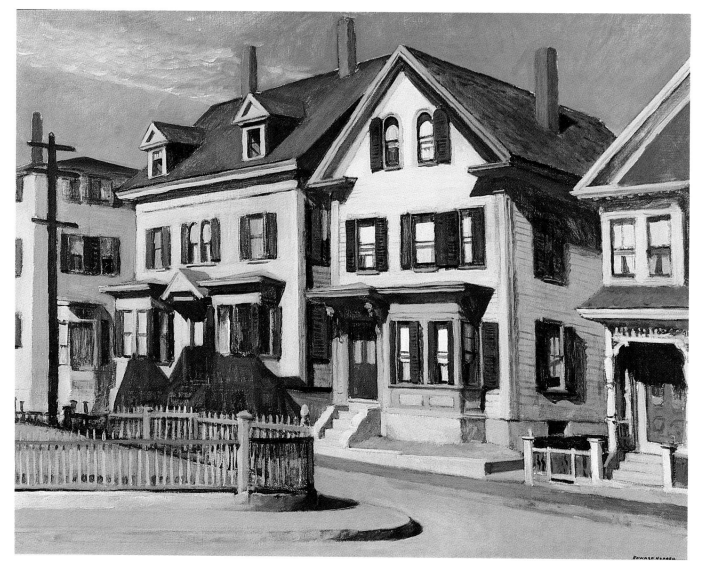

10. *Gloucester Street*

18

CATALOGUE

Most of the oils and watercolors in this exhibition have extensive bibliographies, However, references here are limited to the following major sources: the Lloyd Goodrich catalogue, *Edward Hopper* (1964), documenting the retrospective exhibition held at the Whitney Museum of American Art, New York, the Art Institute of Chicago, Illinois, the Detroit Institute of Arts, Michigan, and the City Art Museum of St. Louis, Missouri; Lloyd Goodrich, *Edward Hopper* (1971); and Gail Levin, *Edward Hopper: The Art and the Artist* (1980), published in conjunction with the Hopper exhibition organized by the Whitney Museum of American Art, New York.

Unless otherwise noted, and with the exception of numbers 2, 3, 4, 5, and 40, all works have the following history of ownership: the artist, until 1967; to his widow Jo Hopper; by bequest to Mrs. Mary R. Schiffenhaus, New Jersey, in 1968; by descent in the Schiffenhaus family, until 1988.

The checklist is arranged chronologically. An asterisk (*) indicates that the work is illustrated.

*1. *Squam Light*

Oil on canvas, 24 x 29 in.
Signed (at lower right): E. HOPPER
Painted in 1912

RECORDED: Gail Levin, *Edward Hopper: The Art and the Artist* (1980), pp. 28, 35, 130 pl. 128 in color

EX COLL.: the artist; to [Frank K.M. Rehn Gallery, New York]; private collection

Squam Light was painted during the summer of 1912 in Gloucester, Massachusetts, and depicts a lighthouse on Cape Ann near Annisquam. Gail Levin observed [*op. cit.*, p. 28] that in this painting Hopper "was largely concerned with rendering solid forms with emphatic lights and shadows."

Lent by a private collection

Illus. p. 14

*2. *American Landscape*

Etching, 7¼ x 13⁷⁄₁₆ in.
Signed in pencil (at lower right): Edward Hopper
Executed in 1920

According to Gail Levin [*Edward Hopper: The Complete Prints* (1979), pp. 10-11] Hopper intended to produce his prints in editions of 100. Whether the stated edition in each case was ever completed, however, is not known.

Illus. p. 15

*3. *Night in the Park*

Etching, 6⁷⁄₈ x 8³⁄₈ in.
Signed in pencil (at lower right): Edward Hopper
Executed in 1921

Illus. p. 15

*4. *Night Shadows*

Etching, 7 x 8⅛ in.
Signed in pencil (at lower right): Edward Hopper
Executed in 1921

In 1924, after the plate was steel faced, an edition of 500 to 600 impressions of *Night Shadows* was printed for inclusion in a portfolio offered to subscribers to *The New Republic* magazine.

Illus. p. 16

*5. *Evening Wind*

Etching, 7 x 8⅛ in.
Signed in pencil (at lower right): Edward Hopper
Executed in 1921

Hopper's etchings, nearly all of which were executed between 1915 and 1923, often foreshadow dominant subjects in his later oils and watercolors. The theme in *Evening Wind*, for example, of a nude woman in a city interior reappears in such paintings as *Morning in a City*, 1924 (oil on canvas, 44 x 60 in., Williams College Museum of Art, Williamstown, Massachusetts), *Eleven A.M.*, 1926 (*cf.* cat. no. 9), and *A Woman in the Sun*, 1961 (*cf.* cat. nos. 97, 98, 99, 100). The isolated house by a railroad shown in *American Landscape* (cat. no. 2) is evoked in paintings such as *House by the Railroad*, 1925 (oil on canvas, 24 x 29 in., The Museum of Modern Art, New York), and *Dauphinée House*, 1932 (cat. no. 21), while the dramatic play of light and shadow in *Night in the Park* (cat. no. 3) and *Night Shadows* (cat. no. 4) is a consistent theme running throughout much of Hopper's later work.

Illus. p. 16

*6. *Houses on the Beach, Gloucester*

Watercolor and graphite on paper, 13¾ x 19⅞ in.

Signed (at lower right): Edward Hopper

Executed about 1923-24

EXHIBITED: Whitney Museum of American Art, New York, 1964, *Edward Hopper*, p. 66 no. 79

EX COLL.: the artist; to [Frank K.M. Rehn Gallery, New York]; to Mr. and Mrs. Daniel Fraad, Scarsdale, New York, in 1956

Collection of Rita and Daniel Fraad

Illus. p. 17

*7. *House in Gloucester*

Watercolor on paper, 13¾ x 20 in.

Signed and inscribed (at lower left): Edward Hopper/Gloucester

Executed in 1924

EX COLL.: the artist; to [Frank K.M. Rehn Gallery, New York]; to Mr. and Mrs. J.T. Spaulding, New York, and New Jersey (friends of the artist), by 1932—until 1986

Hopper first visited the coastal town of Gloucester, Massachusetts, during the summer of 1912. He returned in 1923 and began recording, in watercolor, its dramatic architectural landscape, often devoid of human forms. Watercolor was not new to Hopper; he had used it earlier in his illustrations. However, it was during the Gloucester summers of 1923 and 1924 that he began to explore its immediacy and nuances while painting out-of-doors, directly from nature.

Illus. p. 20

*8. *House and Harbor, Gloucester*

Watercolor on paper, 14 x 20 in.

Signed, dated, and inscribed (at lower left): Edward Hopper/Gloucester 1924

RECORDED: Lloyd Goodrich, *Edward Hopper* (1971), p. 178 illus.

EXHIBITED: Whitney Museum of American Art, New York, 1964, *Edward Hopper*, p. 66 no. 82

EX COLL.: the artist; to [Frank K.M.

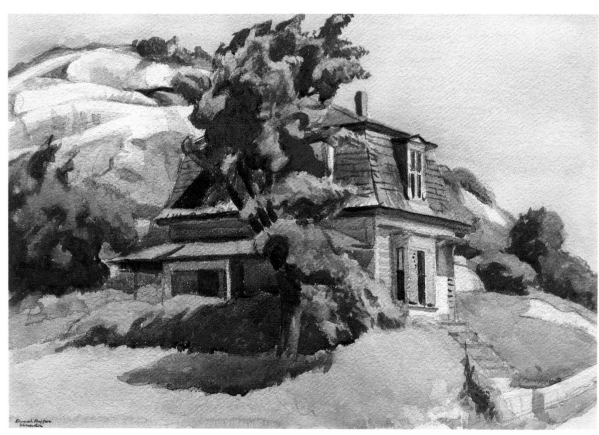

7. House in Gloucester

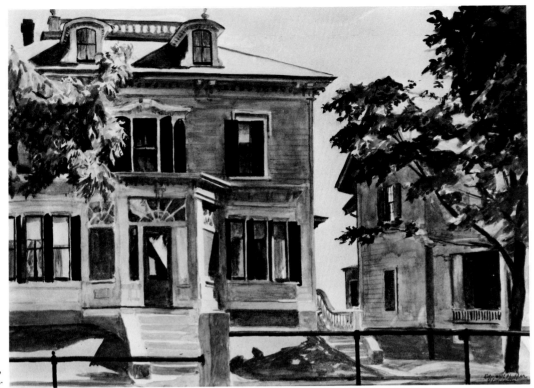

11. *Davis House, Gloucester*

Rehn Gallery, New York]; [M. Knoedler & Co., New York]; to Mr. and Mrs. George Greenspan, New York, about 1955-60

Lent by Mr. and Mrs. George Greenspan

Illus. p. 13

9. *Study for "Eleven A.M."*

Charcoal on beige paper, 6¾ x 9½ in.
Executed about 1926

This work is a preliminary drawing for *Eleven A.M.*, 1926 (oil on canvas, 28⅛ x 36⅛ in., Hirshhorn Museum and Sculpture Garden, Smithsonian Institution, Washington, D.C.).

*10. *Gloucester Street*

Oil on canvas, 28 x 36 in.
Signed (at lower right): EDWARD HOPPER
Painted in 1926

RECORDED: Lloyd Goodrich, *Edward Hopper* (1971), p. 187 illus.

EX COLL.: the artist; to [Frank K.M. Rehn Gallery, New York]; to Joseph H. Hirshhorn, 1954-56; to private collection, New York, 1956-87

Hopper visited Gloucester for the fourth time in the fall of 1926. According to Gail Levin in *Hopper's Places* (1985), pp. 51-52, the artist worked primarily in the center of town during his stay. This painting depicts the corner of Church and Pine Streets. Levin noted: "This canvas resembles the watercolors in subject matter and composition, with cropped buildings on both sides." She continued: "Today, except for color, this row of houses appears much the same as it did to Hopper. Only incidental changes have occurred.... The play of sunlight falling on the architecture still animates the scene with light and shadow, although the bright polychrome Hopper depicted has now been replaced by a uniform white, calling less attention to the houses' eccentric forms and individuality."

Illus. p. 18

*11. *Davis House, Gloucester*

Watercolor on paper, 14 x 20 in.
Signed and inscribed (at lower right): Edward Hopper/Gloucester
Executed in 1926

EXHIBITED: Whitney Museum of American Art, New York, Art Institute of Chicago, Illinois, Detroit Institute of Arts, Michigan, and City Art Museum of St. Louis, Missouri, 1964-65, *Edward Hopper*, p. 66 no. 86

EX COLL.: the artist; to [Frank K.M. Rehn Galleries, New York]; to [Hirschl & Adler Galleries, New York, 1961]; to Mr. and Mrs. J. W. Middendorf II, New York, 1961-66; to [Hirschl & Adler Galleries, New York, 1966]; to Mr. and Mrs. Mortimer Spiller, Buffalo, New York, in 1966

Lent by Mr. and Mrs. Mortimer Spiller

Illus. p. 21

*12. *Lime Rock Quarry No. 1*

Watercolor on paper, 14 x 20 in.
Signed and inscribed (at lower right):
Edward Hopper/Rockland Me.
Executed in 1926

EX COLL.: the artist; to [Frank K.M. Rehn Gallery, New York]; to private collection, about 1956–until 1988

In the summer of 1926 Hopper took a trip to Maine, visiting Eastport, Bangor, and Rockland. It was during the seven weeks that he stayed in Rockland that this watercolor was executed.

Illus. p. 24

*13. *Captain Upton's House*

Oil on canvas, 28½ x 36¼ in.
Signed (at lower right): EDWARD
HOPPER
Painted in 1927

RECORDED: Lloyd Goodrich, *Edward Hopper* (1971), pp. 54-55, 68 illus.

EX COLL.: the artist; to [Frank K.M. Rehn Gallery, New York, 1927-29]; to George Jones Dyer, Norfolk, Connecticut, 1929; to his niece, Mrs. Yale Kneeland, Jr., Millbrook, New York, by 1950–until 1978; to [Andrew Crispo Gallery, New York, by 1983–until 1987]

Hopper was drawn to the isolated monumentality of New England's lighthouses, focusing on this theme in 1926 and 1927. Lloyd Goodrich, in the 1964-65 Hopper retrospective catalogue (p. 20), wrote: "On the rocky point of Cape Elizabeth he found Two Lights with its white Coast Guard station and cottages dominated by the 120-foot-high lighthouse.... The noble forms of the white lighthouse [tower] and the buildings grouped around [it], seen in the clear air and sunlight of Maine, inspired some of his best watercolors, as well as three oils: *Captain Upton's House*, *Lighthouse Hill* [Dallas Museum of Fine Arts, Texas] and *Lighthouse at Two Lights* [Metropolitan Museum of Art, New York]."

Illus. p. 23

*14. *Bill Latham's House, Two Lights*

Watercolor on paper, 14 x 20 in.
Signed and inscribed (at lower right):
Edward Hopper/Two Lights Me.
Executed in 1927

EX COLL.: the artist; to [Frank K.M. Rehn Gallery, New York, in 1927]; to Charles Hovey Pepper, Brookline, Massachusetts, in 1927; to Eunice Pepper Langenbach, until 1961; to Mr. and Mrs. James M. Perkins, Newton, Massachusetts, in 1961; [Hirschl & Adler Galleries, New York, 1985]; to Kathryn and Robert Steinberg, New York, in 1985

Lent by Kathryn and Robert Steinberg

Illus. p. 13

*15. *Blackwell's Island*

Oil on canvas, 25 x 60 in.
Signed (at lower right): EDWARD
HOPPER
Painted in 1928

RECORDED: Lloyd Goodrich, *Edward Hopper* (1971), p. 203 illus. // Gail Levin, *Edward Hopper: The Art and the Artist* (1980), pp. 46, 192 pl. 245

EXHIBITED: Whitney Museum of American Art, New York, 1964, *Edward Hopper*, p. 64 no. 15

EX COLL.: the artist; to [Frank K.M. Rehn Gallery, New York]; private collection; by descent in the family

Hopper painted an early version of *Blackwell's Island* (now called Roosevelt Island), New York, in 1911 (oil on canvas, 24 x 29 in., Whitney Museum of American Art, New York). In this later work, as noted by Gail Levin [*op. cit.*, p. 46], Hopper "...paid more attention to the architecture than to the misty atmosphere of the river." Levin concluded: "Clearly his interest in structure had developed since he had first considered the island."

Private Collection, on extended loan to Vassar College Art Gallery, Poughkeepsie, New York

Illus. p. 25

*16. *Study for "Blackwell's Island"*

Charcoal on paper, 8⅝ x 11⅝ in.
Executed about 1928

EX COLL.: the artist, until 1967; to his widow Jo Hopper; to Reverend and Mrs. Arthayer R. Sanborn, Nyack, New York, and Florida, until 1988

Another drawing for *Blackwell's Island* is in the collection of the Whitney Museum of American Art, New York.

Illus. p. 25

*17. *Maine in Fog*

Charcoal on paper, 15 x 22 in.
Signed and inscribed (at lower right):
Maine in Fog/Edward Hopper
Executed about 1926-29

EX COLL.: [Bernard Danenberg Galleries, New York]; private collection, New York, until 1987

This drawing is a finished study for *Maine in Fog*, 1926-29 (oil on canvas, 34½ x 59 in., Whitney Museum of American Art, New York).

Illus. p. 26

*18. *Corn Hill*

Oil on canvas, 29 x 43 in.
Signed (at lower right): EDWARD
HOPPER
Painted in 1930

RECORDED: Gail Levin, *Edward Hopper: The Art and the Artist* (1980), pp. 63, 281 pl. 405 in color

EX COLL.: the artist; to [Frank K.M. Rehn Gallery, New York]; to Mrs. John O. Blanchard, New York; [M. Knoedler & Co., New York]; to Mr. and Mrs. Sylvan Lang, in 1958; by gift to Marion Koogler McNay Art Museum, San Antonio, Texas, in 1975

Corn Hill is one of Hopper's earliest Cape Cod paintings. In 1930 he and his wife spent their first summer on Cape Cod, where they rented a cottage in South Truro from A. B. Cobb. They stayed in Cobb's

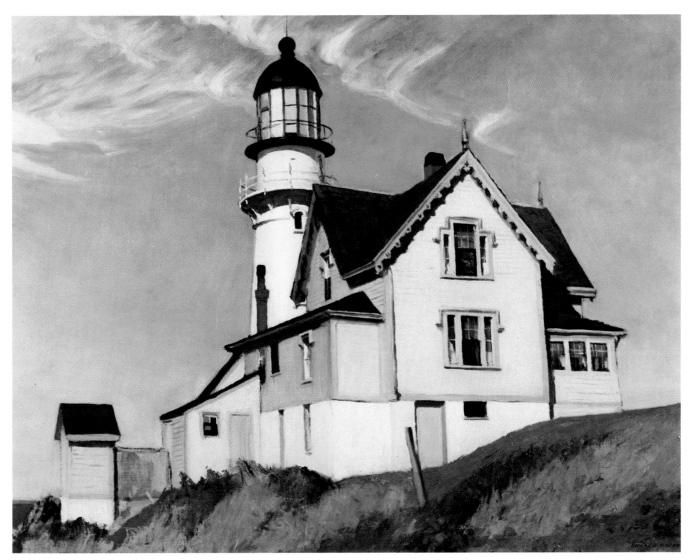

13. *Captain Upton's House*

cottage for the next three summers until construction on their own house in South Truro was completed. From then on, the Hoppers spent six months of nearly every year there and most of his landscapes after 1930 were based on Cape Cod subjects.

Lent by Marion Koogler McNay Art Museum, The Sylvan and Mary Lang Collection.

Illus. p. 27

*19. *Corn Hill*

Watercolor on paper, 14 x 20 in.
Signed and inscribed (at lower right): Edward Hopper/Corn Hill
Executed about 1930

EXHIBITED: Whitney Museum of American Art, New York, and Art Institute of Chicago, Illinois, 1964-65, *Edward Hopper*, p. 67 no. 106

EX COLL.: the artist; to [Frank K.M. Rehn Gallery, New York]; to Keith H. Baker; to [Hirschl & Adler Galleries, New York, 1986]; to The Shearson Lehman Hutton Collection, in 1986

Lent by The Shearson Lehman Hutton Collection

Illus. p. 27

*20. *Rich's Barn, South Truro*

Watercolor on paper, 20 x 28 in.
Signed (at lower right): EDWARD HOPPER
Executed in 1931

RECORDED: Lloyd Goodrich, *Edward Hopper* (1971), p. 216 illus.

EXHIBITED: Whitney Museum of American Art, New York, Art Institute of Chicago, Illinois, Detroit Institute of Arts, Michigan, and City Art Museum of St. Louis, Missouri, 1964-65, *Edward Hopper*, p. 67 no. 110

EX COLL.: the artist; to [Frank K.M. Rehn Gallery, New York]; to private collection, about 1931-35; by descent in the family

Lent by a private collection

Illus. p. 28

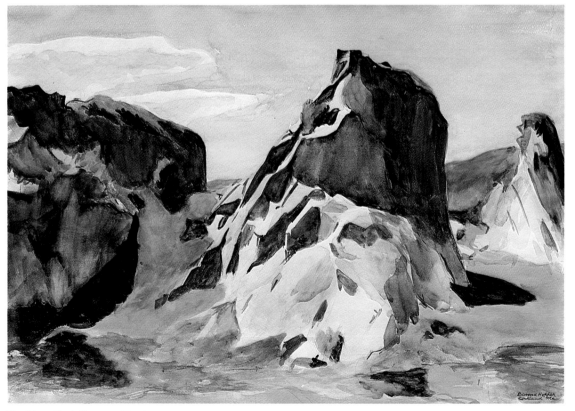

12. *Lime Rock Quarry No. 1*

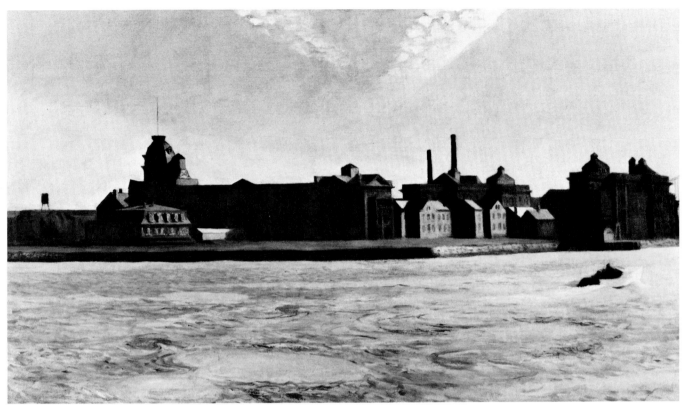

15. *Blackwell's Island*. Private Collection on loan to Vassar College Art Gallery L81.2

16. *Study for "Blackwell's Island"*

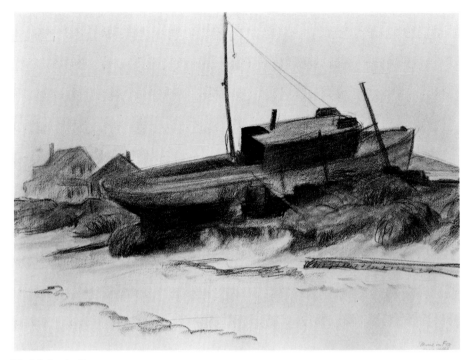

17. *Maine in Fog*

21. *Dauphinée House

Oil on canvas, 34 x 50¼ in.
Signed (at lower right): EDWARD
HOPPER
Painted in 1932

RECORDED: Gail Levin, *Edward Hopper:
The Art and the Artist* (1980), p. 288 pl.
415 in color

EX COLL.: the artist; to [Frank K.M.
Rehn Gallery, New York]; to Huntington
Hartford, California, 1967; to [Kennedy
Galleries, New York]; to Richard Man-
oogian, Grosse Pointe, Michigan, 1980;
to [Andrew Crispo Gallery, New York,
until 1987]

The house depicted here was just a short
walk from Hopper's home in South Truro.
It also appeared as *Captain Kelly's House*,
1931 (watercolor on paper, 20 x 24⅞ in.,
Whitney Museum of American Art, New
York) and in *Railroad Embankment*, 1932
(watercolor on paper, 14 x 20 in., private
collection). Eventually the house was pur-

chased by Hopper's friend and fellow artist
Henry Varnum Poor. Gail Levin has noted
[*Hopper's Places* (1985), p. 71]: "Although
grey shingles have been added to one side
of this house, the shutters are painted a
darker color, and shrubbery has been
planted, the house still stands alone, iso-
lated in a clearing, its simple geometric
structure in sharp contrast to the gentle
curves of the surrounding hills."

Illus. p. 30

22. *Cottages at Wellfleet

Watercolor on paper, 20 x 28 in.
Signed (at lower right): Edward Hopper
Executed in 1933

RECORDED: Lloyd Goodrich, *Edward
Hopper* (1971), p. 223 illus. in color

EXHIBITED: Whitney Museum of Ameri-
can Art, New York, Art Institute of Chi-
cago, Illinois, Detroit Institute of Arts,
Michigan, and City Art Museum of St.

Louis, Missouri, 1964-65, *Edward Hop-
per*, pp. 31 illus. in color, 67 no. 113

EX COLL.: the artist; to [Frank K.M.
Rehn Gallery, New York]; to Mr. and
Mrs. John Clancy; to private collection,
about 1960-65

Lent by a private collection
Illus. p. 29

23. *Wellfleet Bridge

Watercolor on paper, 13⅜ x 19⁵⁄₁₆ in.
(sight size)
Signed and inscribed (at lower right):
Edward Hopper/Wellfleet
Executed about 1933-34

EX COLL.: the artist; to [Frank K.M.
Rehn Gallery, New York]; to private col-
lection, about 1934-40; by descent in the
family

Lent by a private collection
Illus. p. 32

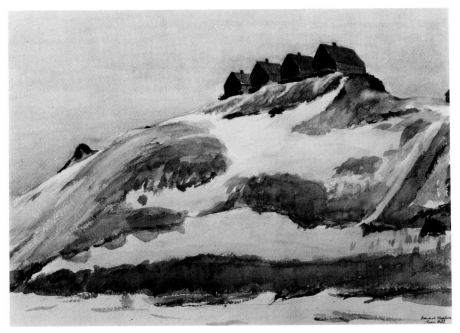

19. *Corn Hill*

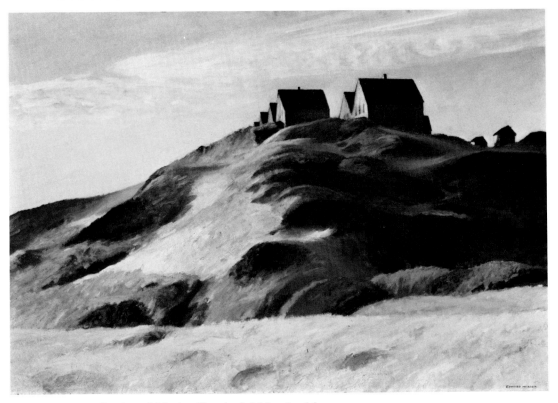

18. *Corn Hill*. Collection of Marion Koogler McNay Art Museum,
 The Sylvan and Mary Lang Collection

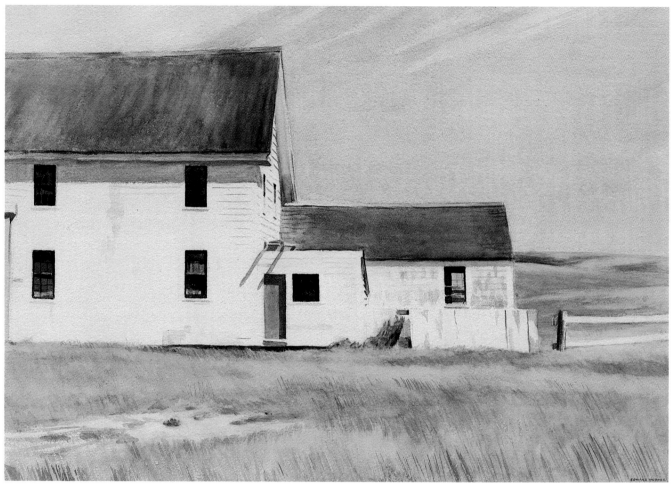

20. *Rich's Barn, South Truro*

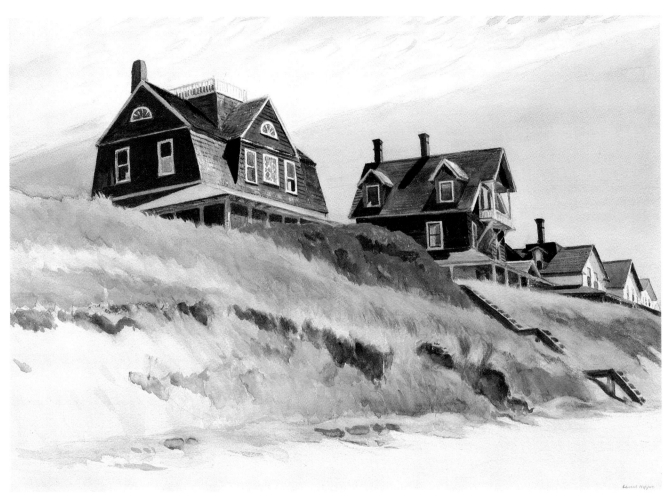

22. *Cottages at Wellfleet*

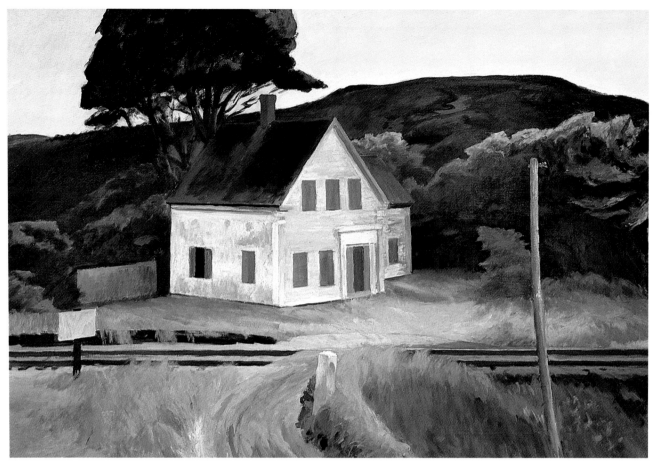

21. *Dauphinée House*

*24. *Double-Sided Studies for "The Long Leg"*

Conte crayon on beige paper, 11 x 8½ in.
Executed about 1935

These drawings are studies for *The Long Leg*, 1935 (oil on canvas, 20 x 30 in., The Virginia Steele Scott Collection at the Henry E. Huntington Library and Art Gallery, San Marino, California).

Illus. p. 43

*25. *House with a Big Pine*

Watercolor on paper, 20 x 25 in.
Signed (at lower left): Edward Hopper
Executed about 1935

RECORDED: Lloyd Goodrich, *Edward Hopper* (1971), p. 229 illus. in color

EXHIBITED: Whitney Museum of American Art, New York, 1964, *Edward Hopper*, p. 67 no. 117

EX COLL.: the artist; to [Frank K.M. Rehn Gallery, New York]; to private collection, about 1935-40

Lent by a private collection

Illus. p. 34

*26. *Provincetown Houses*

Charcoal on paper, 10¼ x 15¹³⁄₁₆ in.
Executed about 1930-40

Illus. p. 35

*27. *House on Cape Cod (The White House)*

Charcoal on paper, 14 x 21 in. (sight size)
Signed (at lower right): Edward Hopper
Executed about 1930-40

EX COLL.: Dorothy Dell Dennison Butler; to [Kennedy Galleries, New York]; private collection

Lent by a private collection

Illus. p. 31

*28. *Cape Cod Crossroads, Trees and Telephone Poles*

Charcoal on paper, 10⅛ x 15⅝ in.
Executed about 1930-40

Illus. p. 36

29. *Cape Cod House*

Charcoal on paper, 10¾ x 15 in.
Executed about 1930-40

30. *House and Figures*

Conte crayon on beige paper, 8½ x 11 in.
Executed about 1930-40

31. *Man at Rail of Docked Ship*

Conte crayon on beige paper, 8½ x 11 in.
Executed about 1930-40

*32. *Houses by a Road*

Charcoal on paper, 10½ x 16 in.
Executed about 1935-45

Illus. p. 37

*33. *Cape Cod Road*

Charcoal on paper, 10½ x 15⅞ in.
Executed about 1935-45

Illus. p. 36

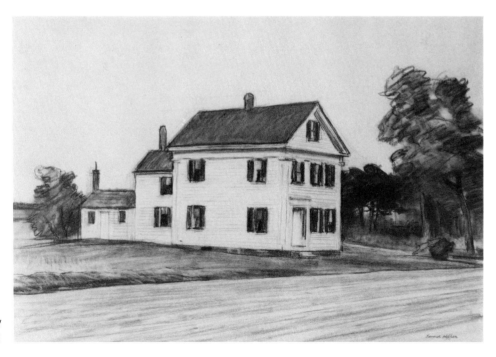

27. *House on Cape Cod (The White House)*

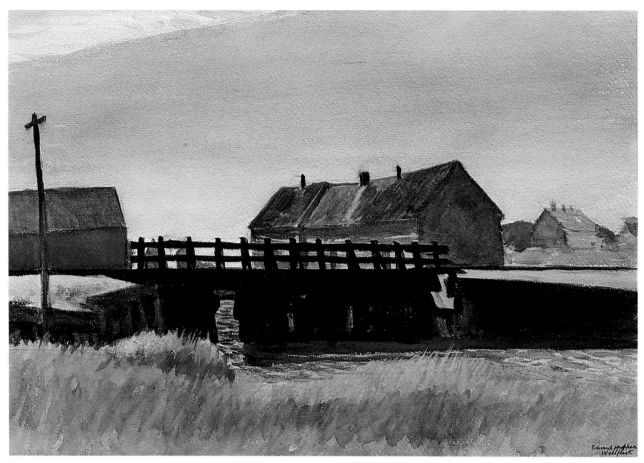

23. *Wellfleet Bridge*

*34. *Sugar Maple*

Watercolor on paper, 14 x 20 in.
Signed (at lower right): EDWARD
HOPPER
Executed in 1938

RECORDED: Gail Levin, *Edward Hopper:
The Art and the Artist* (1980), p. 229 pl.
319 in color

EX COLL.: The Museum of Modern Art,
New York, Lending Library; to [William
Zierler, New York]; to Mr. and Mrs. Joel
W. Harnett, about 1955-60

Collection of Mr. and Mrs. Joel W.
Harnett

Illus. p. 35

*35. *Along the Road, Tree and
Distant House*

Charcoal on paper, 10¼ x 15⅞ in.
Executed about 1935-45

Illus. p. 34

36. *Collie*

Pencil on paper, 6 x 6⅞ in.
Executed about 1935-45

This drawing may be a preparatory study
for the collie in *Cape Cod Evening*, 1939
(oil on canvas, 30¼ x 40¼ in., National
Gallery of Art, Washington, D.C.).

37. *Sailboats under a Bridge*

Charcoal on beige paper, 8½ x 11 in.
Executed about 1935-45

EX COLL.: the artist, until 1967; to his
widow Jo Hopper; to Reverend and Mrs.
Arthayer R. Sanborn, Nyack, New York,
and Florida, until 1988

On the back of this drawing is another that
depicts houses at a crossroads.

38. *Sailboat*

Pencil on beige paper, 8½ x 11 in.
Executed about 1935-45

39. *Studies of Sailboats*

Pencil on beige paper, 8½ x 11 in.
Executed about 1935-45

*40. *Study for "Light Battery at
Gettysburg"*

Charcoal and white chalk on paper,
16 x 24 in.
Signed twice (at lower left): Edward Hop-
per; (at lower right): Edward Hopper
Executed about 1940

This drawing is a finished study for *Light
Battery at Gettysburg*, 1940 (oil on canvas,
18 x 27 in., Nelson-Atkins Museum of
Art, Kansas City, Missouri). Another
drawing for the painting is in the collection
of the Whitney Museum of American Art,
New York.

Illus. p. 40

*41. *Gas*

Oil on canvas, 26¼ x 40¼ in.
Signed (at lower right): EDWARD
HOPPER
Painted in 1940

RECORDED: Lloyd Goodrich, *Edward
Hopper* (1971), pp. 119, 129, 135 illus. in
color // Gail Levin, *Edward Hopper: The
Art and the Artist* (1980), pp. 50, 208 pl.
275 in color

EXHIBITED: Whitney Museum of Ameri-
can Art, New York, Art Institute of Chi-
cago, Illinois, Detroit Institute of Arts,
Michigan, and City Art Museum of St.
Louis, Missouri, 1964-65, *Edward Hop-
per*, pp. 23 illus. in color, 46, 65 no. 38

EX COLL.: the artist; to [Frank K.M.
Rehn Gallery, New York]; to The
Museum of Modern Art, New York, in
1943

Lloyd Goodrich wrote in the Whitney
Museum exhibition catalogue [*op. cit.*,
p. 46]: "In composing *Gas*, . . . [Hopper]
searched for a filling station like the one he
had in his mind; not finding one, he made
up his station out of parts of several—but
the pumps were studied from real ones.
The degree of transformation varies; but

almost all his mature oils are composites."
Goodrich continued: "When you ask him
where the subject of a painting is, he says
'Nowhere' or 'In here,' tapping his fore-
head. Through this inner process his sub-
ject transcends the specific and takes on a
broader and deeper meaning."

Lent by The Museum of Modern Art,
New York, Mrs. Simon Guggenheim
Fund, 1943

Illus. p. 38

*42. *Study for "Gas"*

Pen and ink on beige paper, 4⅝ x 7½ in.
Executed about 1940

Other drawings for *Gas* are in the collec-
tion of the Whitney Museum of American
Art, New York.

Illus. p. 39

*43. *Two Studies for "Gas"*

Conte crayon on beige paper, 11 x 8½ in.
Executed about 1940

Illus. p. 39

44. *Two Sketches for "Gas"*

Conte crayon on paper, 11 x 8½ in.
Executed about 1940

*45. *Study of Mountains*

Charcoal on paper, 10 x 15½ in.
Executed about 1941

In the summer of 1941 Edward and Jo
Hopper traveled to the West Coast by car,
visiting Colorado, Utah, Wyoming, and
Yellowstone National Park. This drawing,
along with number 46, was probably
executed during their trip through the
Rocky Mountains.

Illus. p. 41

46. *Mountain Landscape*

Charcoal on paper, 10¼ x 16 in.
Executed about 1941

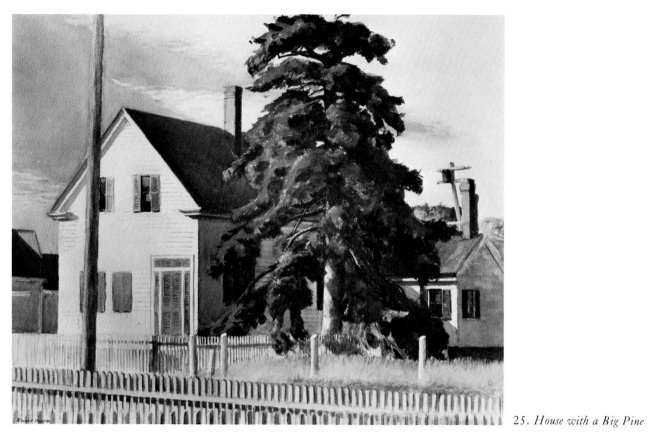

25. House with a Big Pine

35. Along the Road,
Tree and Distant House

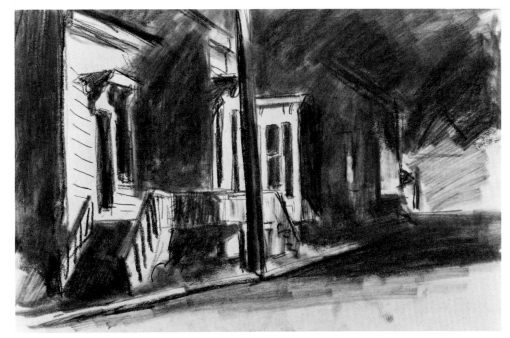

26. *Provincetown Houses*

34. *Sugar Maple*

35

47. *Motel with Car Out Front*

Conte crayon on beige paper, 6 x 9½ in.
Executed about 1941-46

*48. *Rooftop View, Saltillo, Mexico*

Charcoal on paper, 10⅛ x 15½ in.
Executed about 1943-51

Hopper traveled to Saltillo in 1943, 1946, and again in 1951. This drawing was undoubtedly executed during one of these trips.

Illus. p. 41

*49. *Study for "The Lee Shore"*

Charcoal on paper, 8½ x 11 in.
Executed about 1941

This drawing and numbers 50, 51, and 52 are studies for *The Lee Shore*, 1941 (oil on canvas, 28¼ x 43 in., private collection).

Illus. p. 42

50. *Two Sketches for "The Lee Shore"*

Conte crayon on beige paper, 11 x 8½ in.
Executed about 1941

*51. *Two Studies for "The Lee Shore"*

Conte crayon on beige paper, 9½ x 7¼ in.
Executed about 1941

On the back of this drawing are studies of a sailboat and a battleship.

Illus. p. 42

52. *Study for the House in "The Lee Shore"*

Charcoal on paper, 10½ x 16 in.
Executed about 1941

28. *Cape Cod Crossroads, Trees and Telephone Poles*

33. *Cape Cod Road*

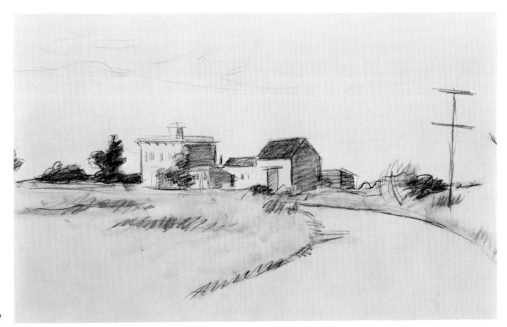

32. *Houses by a Road*

*53. *Portrait of Colonel Magee**

Charcoal on paper, 15½ x 9½ in.
Executed about 1940-50

Colonel Magee was a neighbor of the Hoppers' in South Truro, Cape Cod.

Illus. p. 45

*54. *Study of a Table and Two Chairs**

Charcoal on paper, 11 x 17¾ in.
Executed about 1940-50

Illus. p. 44

*55. *Jo Hopper Reading**

Conte crayon on paper, 15⅞ x 10⅜ in.
Executed about 1943

This drawing is possibly a study for *Hotel Lobby*, 1943 (oil on canvas, 32½ x 40¾ in., Indianapolis Museum of Art, Indiana).

Illus. p. 45

*56. *Two Puritans**

Oil on canvas, 30 x 40 in.
Signed (at lower left): EDWARD HOPPER
Painted in 1945

RECORDED: Gail Levin, *Edward Hopper: The Art and the Artist* (1980), pp. 44-45, 50, 184 pl. 231 in color

EXHIBITED: Whitney Museum of American Art, New York, 1964, *Edward Hopper*, p. 65 no. 48

EX COLL.: the artist; to [Frank K.M. Rehn Gallery, New York]; to [Athena Gallery, New Haven, Connecticut]; to private collection, 1962–until 1988

Of this work Gail Levin has written [*op. cit.*, pp. 44-45]: "In *Two Puritans* (1945), the houses seem strangely animated, as if they had personalities all their own. The windows, shutters, and doors read almost like facial features, elements of personalities that make their presence felt." Levin continued: "Then, too, this work has a strange, subtle tonality recalling early canvases like *Blackwell's Island* of 1911 [oil on canvas, 24 x 29 in., Whitney Museum of American Art, New York] and *Moonlight*

Interior of about 1921-23 [oil on canvas, 24 x 29 in., private collection]."

Illus. p. 4

*57. *Study for "Two Puritans"**

Conte crayon on beige paper, 7¼ x 10 in.
Executed about 1945

Illus. p. 47

*58. *Sketch for "Two Puritans"**

Conte crayon on beige paper, 7 x 9½ in.
Executed about 1945

59. *Study of Roof and Trees*

Charcoal on paper, 10⅛ x 15⅞ in.
Executed about 1940-50

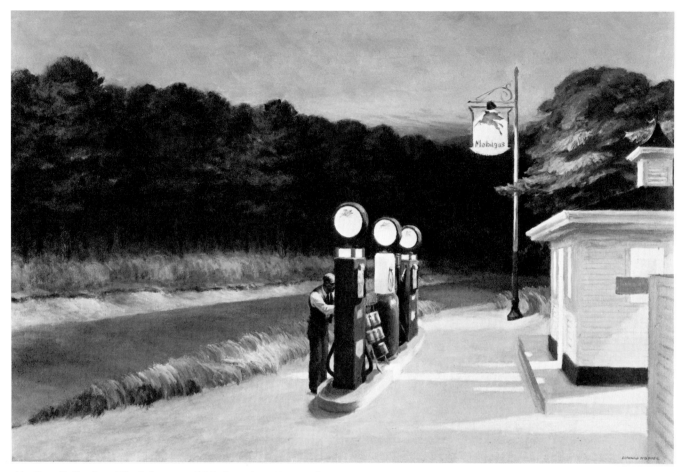

41. *Gas*. Collection, The Museum of Modern Art, New York. Mrs. Simon Guggenheim Fund, 1943

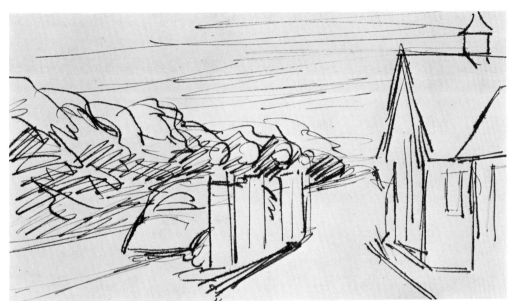

42. *Study for "Gas"*

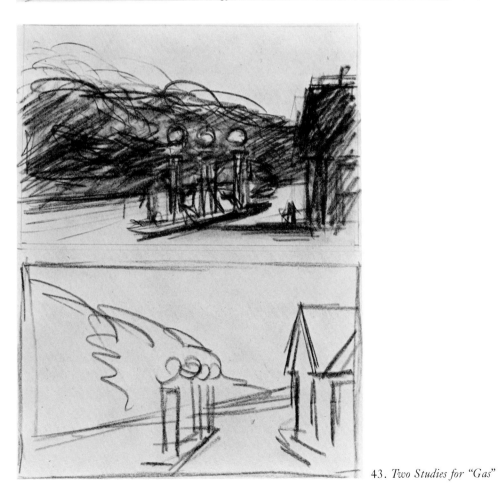

43. *Two Studies for "Gas"*

39

*60. *October on Cape Cod*

Oil on canvas, 26 x 42 in.
Signed (at lower right): EDWARD
HOPPER
Painted in 1946

RECORDED: Lloyd Goodrich, *Edward Hopper* (1971), p. 272 illus. // Gail Levin, *Edward Hopper: The Art and the Artist* (1980), p. 292 pl. 420 in color

EXHIBITED: Whitney Museum of American Art, New York, Art Institute of Chicago, Illinois, Detroit Institute of Arts, Michigan, and City Art Museum of St. Louis, Missouri, 1964-65, *Edward Hopper*, p. 65 no. 50

EX COLL.: the artist; to [Frank K.M. Rehn Gallery, New York]; to Katherine and William Carpenter; Dr. Theodore Leshner, Brooklyn, New York; to [Hirschl & Adler Galleries, New York, 1971]; to [James Goodman Gallery, New York]; to private collection, in 1971

Lent by a private collection

Illus. p. 46

*61. *Study for "October on Cape Cod"*

Charcoal on paper, 12⅜ x 18⅜ in.
Executed about 1946

Illus. p. 46

62. *Double-Sided Study for "October on Cape Cod"*

Conte crayon on paper, 5¾ x 9¾ in.
Executed about 1946

63. *Double-Sided Sketch for "October on Cape Cod"*

Conte crayon on beige paper, 7 x 9⅞ in.
Executed about 1946

*64. *Seven A.M.*

Oil on canvas, 30 x 40 in.
Signed (at lower right): EDWARD
HOPPER
Painted in 1948

RECORDED: Lloyd Goodrich, *Edward Hopper* (1971), p. 273 illus. // Gail Levin, *Edward Hopper: The Art and the Artist* (1980), pp. 63, 271 pl. 388 in color

EXHIBITED: Whitney Museum of American Art, New York, Art Institute of Chicago, Illinois, Detroit Institute of Arts, Michigan, and City Art Museum of St. Louis, Missouri, 1964-65, *Edward Hopper*, p. 65 no. 53

EX COLL.: the artist; to [Frank K.M. Rehn Gallery, New York]; to Whitney Museum of American Art, New York, in 1950

Lent by the Whitney Museum of American Art, New York; Purchase and exchange. 50.8

Illus. p. 48

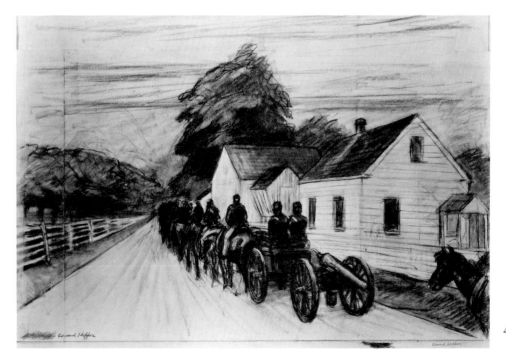

40. *Study for "Light Battery at Gettysburg"*

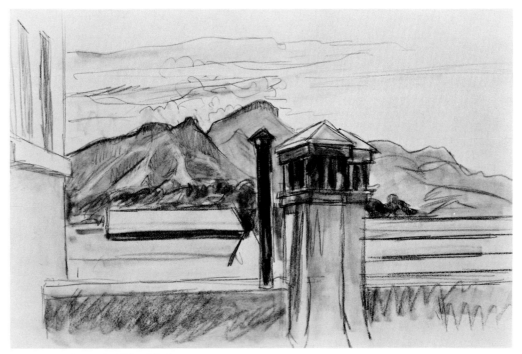

48. *Rooftop View, Saltillo, Mexico*

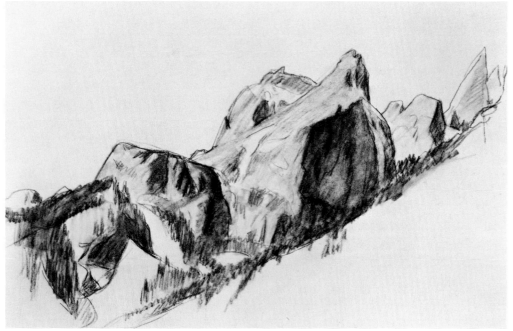

45. *Study of Mountains*

65. *Storefront, Study for "Seven A.M."*

Conte crayon on beige paper, 7½ x 8⅜ in.
Executed about 1948

*66. *Study for "Seven A.M."*

Conte crayon on beige paper, 7⅜ x 9⅝ in.
Executed about 1948
Illus. p. 49

67. *Sketch for "Seven A.M."*

Conte crayon on beige paper, 7¾ x 9½ in.
Executed about 1948

68. *Storefront*

Conte crayon on paper, 10⅜ x 15⅞ in.
Executed about 1948

This drawing is possibly a study for *Seven A.M.* (cat. no. 64).

69. *Storefront in a City*

Charcoal on beige paper, 8¼ x 11 in.
Executed about 1948-62

Ex COLL.: the artist, until 1967; to his widow Jo Hopper; to Reverend and Mrs. Arthayer R. Sanborn, Nyack, New York, and Florida, until 1988

*70. *High Noon*

Oil on canvas, 28 x 40 in.
Signed (at lower right): EDWARD HOPPER
Painted in 1949

RECORDED: Lloyd Goodrich, *Edward Hopper* (1971), pp. 133, 146 illus. in color, 149 // Gail Levin, *Edward Hopper: The Art and the Artist* (1980), pp. 42, 63, 276 pl. 398 in color

EXHIBITED: Whitney Museum of American Art, New York, Art Institute of Chicago, Illinois, Detroit Institute of Arts, Michigan, and City Art Museum of St. Louis, Missouri, 1964-65, *Edward Hopper*, pp. 50 illus., 52, 55, 65 no. 55

49. Study for "The Lee Shore"

51. Two Studies for "The Lee Shore"

24. *Double-Sided Studies
for "The Long Leg"*

EX COLL.: the artist; to [Frank K.M. Rehn Gallery, New York]; to Mr. and Mrs. Anthony Haswell; by gift to The Dayton Art Institute, Ohio, in 1971

In writing about this painting Lloyd Goodrich observed [*op. cit.*, p. 149]: "[Hopper's] style showed no sign of softening with the years. Particularly in his last fifteen years or so, certain paintings revealed their rectilinear and angular structure even more clearly. *High Noon*, for example, is almost pure geometry; the dominant straight lines and acute angles, the emphatic pattern of sunlight and shadow, the extreme simplification and utter clarity—all create a design that has interesting parallels with geometric abstraction. . . ."

Lent by The Dayton Art Institute, Ohio, Gift of Mr. and Mrs. Anthony Haswell

Illus. p. 50

*71. *Figure Study for "High Noon"*

Charcoal on paper, 12¾ x 7⅞ in.
Executed about 1949

Illus. p. 51

72. *Compositional Sketch for
"High Noon"*

Conte crayon on beige paper, 8½ x 11 in.
Executed about 1949

*73. *Double-Sided Study for
"High Noon"*

Conte crayon on beige paper, 7¼ x 9 in.
Executed about 1949

Illus. p. 51

74. *Architectural Study with
Dormer Window*

Pencil on paper, 8¹¹⁄₁₆ x 11¹¹⁄₁₆ in.
Executed about 1949

This drawing and number 75 are probably studies for *High Noon* (cat. no. 70).

75. *Architectural Study*

Conte crayon on paper, 8⅝ x 11⅝ in.
Executed about 1949

76. *Trees and Stream*

Conte crayon on paper, 10⅛ x 14½ in.
Executed about 1945-55

*77. *Study for "Portrait of Orleans"*

Conte crayon on paper, 10 x 15½ in. (sight size)

Executed about 1950

EX COLL.: estate of the artist

As noted by Gail Levin, this drawing is a study for *Portrait of Orleans*, 1950 (oil on canvas, 26 x 40 in., private collection).

Illus. p. 52

*78. *Cape Cod Morning*

Oil on canvas, 34½ x 40⅛ in.

Signed (at lower right): EDWARD HOPPER

Painted in 1950

RECORDED: Lloyd Goodrich, *Edward Hopper* (1971), p. 275 illus. in color // Gail Levin, *Edward Hopper: The Art and the Artist* (1980), pp. 63, 277 pl. 399 in color

EXHIBITED: Whitney Museum of American Art, New York, Art Institute of Chicago, Illinois, Detroit Institute of Arts, Michigan, and City Art Museum of St. Louis, Missouri, 1964-65, *Edward Hopper*, pp. 48 illus., 65 no. 56

EX COLL.: the artist; to [Frank K.M. Rehn Gallery, New York]; to The Sara Roby Foundation, in 1955; by gift to National Museum of American Art, Smithsonian Institution, Washington, D.C., in 1985

Gail Levin observed [*op. cit.*, p. 63]: "A sense of longing appears to be Hopper's major association with morning. This seems especially apparent in works like . . . *Cape Cod Morning* of 1950, where a woman in a red dress leans out to observe the world from her bay window."

Lent by the National Museum of American Art, Smithsonian Institution, Gift of the Sara Roby Foundation

Illus. p. 54

*79. *Architectural Studies for "Cape Cod Morning"*

Charcoal on paper, 8⅝ x 11⅝ in.

Executed about 1950

The study of the door to the right in this drawing directly relates to the doorway of the house in *Cape Cod Evening*, 1939 (oil on canvas, 30 x 40 in., National Gallery of Art, Washington, D.C.).

Illus. p. 7

*80. *Figure in Window, Study for "Cape Cod Morning"*

Charcoal on beige paper, 7⅛ x 8 in.

Executed about 1950

Illus. p. 55

81. *Study for "Cape Cod Morning" (Woman in Bay Window)*

Sanguine on paper, 7⅝ x 9⅝ in.

Executed about 1950

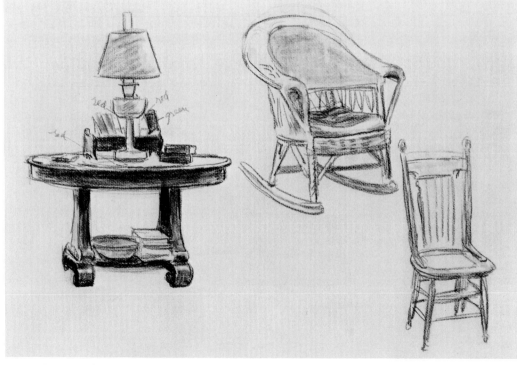

54. *Study of a Table and Two Chairs*

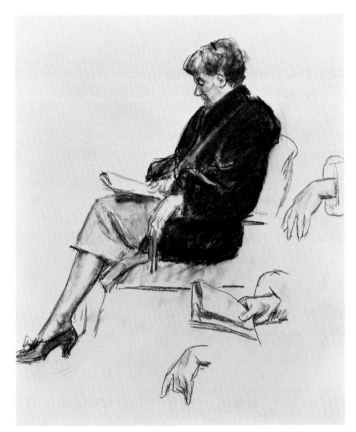

55. *Jo Hopper Reading*

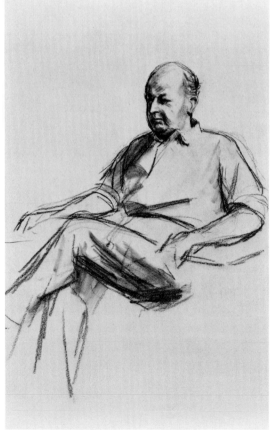

53. *Portrait of Colonel Magee*

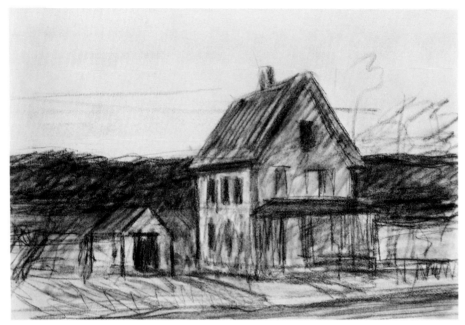

61. *Study for "October on Cape Cod"*

60. *October on Cape Cod*

82. *Double-Sided Study for "Cape Cod Morning"*

Sanguine on beige paper, 11 x 8½ in.
Executed about 1950

*83. *Figure Study for "Cape Cod Morning"*

Charcoal on paper, 11⅝ x 8⅝ in.
Executed about 1950

Illus. p. 55

84. *Sketch for "Cape Cod Morning"*

Sanguine on beige paper, 11 x 8½ in.
Executed about 1950

85. *Tree Study*

Charcoal on paper, 10⅜ x 15⅞ in.
Executed about 1950

This drawing is possibly a study for *Cape Cod Morning* (cat. no. 78).

86. *Tree and Landscape Studies*

Charcoal on paper, 10⅛ x 15⅞ in.
Executed about 1950-60

87. *Study for "Hotel by a Railroad"*

Conte crayon on beige paper, 7½ x 9 in.
Executed about 1952

This drawing is a preliminary study for *Hotel by a Railroad*, 1952 (oil on canvas, 31 x 40 in., Hirshhorn Museum and Sculpture Garden, Smithsonian Institution, Washington, D.C.). Other drawings for the painting are in the collection of the Whitney Museum of American Art, New York.

*88. *Study for "Seawatchers"*

Conte crayon on beige paper, 8½ x 11 in.
Executed about 1952

This drawing and numbers 89 and 90 are studies for *Seawatchers*, 1952 (oil on canvas, 30 x 40 in., private collection).

Illus. p. 53

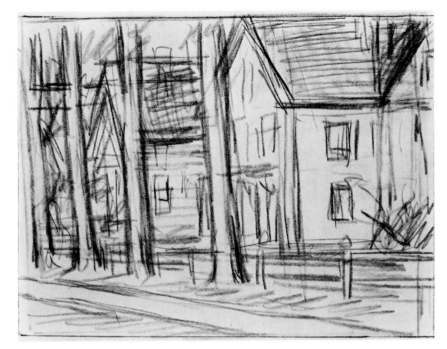

57. Study for "Two Puritans"

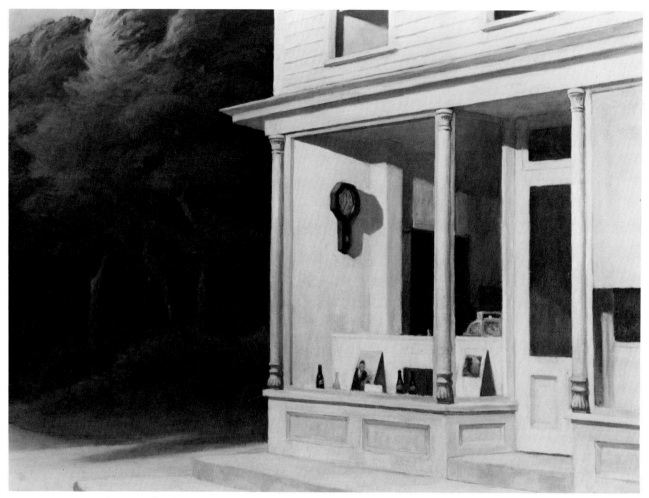

64. *Seven A.M.* Collection of Whitney Museum of American Art, New York; Purchase and exchange. 50.8

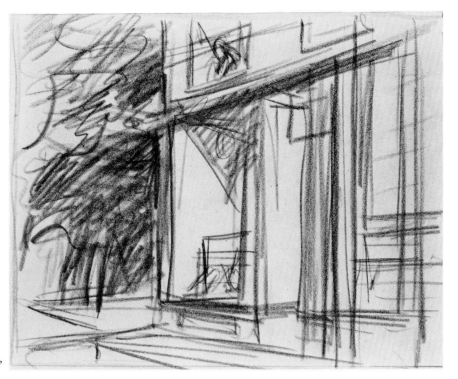

66. Study for "Seven A.M."

89. *Sketch for "Seawatchers"*

Conte crayon on beige paper, 7 x 10 in.
Executed about 1952

*90. *Female Figure Study for
"Seawatchers"*

Charcoal on paper, 14⅞ x 12¾ in.
Executed about 1952

Illus. p. 53

91. *Study of a House on Cape Cod*

Conte crayon on beige paper, 7 x 8½ in.
Executed about 1950-60

92. *Cape Cod House by the Sea*

Conte crayon on beige paper, 7⅛ x 9 in.
Executed about 1950-60

93. *Two Figures (Study for
"Sunlight on Brownstones")*

Charcoal on beige paper, 8½ x 11 in.
Executed about 1956

EX COLL.: the artist, until 1967; to his
widow Jo Hopper; to Reverend and Mrs.
Arthayer R. Sanborn, Nyack, New York,
and Florida, until 1988

This drawing is a study for *Sunlight on
Brownstones*, 1956 (oil on canvas, 29¾ x
39¾ in., Wichita Art Museum, Kansas;
The Roland P. Murdock Collection).

94. *Figure Studies for
"Western Motel"*

Charcoal on paper, 17¾ x 11⅞ in.
Executed about 1957

This drawing is a study for the figure in
Western Motel, 1957 (oil on canvas, 30¼ x
60⅛ in., Yale University Art Gallery,
New Haven, Connecticut).

95. *Study for "Excursion into
Philosophy"*

Charcoal on beige paper, 7 x 9¼ in.
Executed about 1959

This drawing is a study for *Excursion into
Philosophy*, 1959 (oil on canvas, 30 x 40
in., private collection).

*96. *Couple Seated in an Interior*

Charcoal on beige paper, 8½ x 11 in.
Executed about 1956-65

EX COLL.: the artist, until 1967; to his
widow Jo Hopper; to Reverend and Mrs.
Arthayer R. Sanborn, Nyack, New York,
and Florida, until 1988

Illus. p. 6

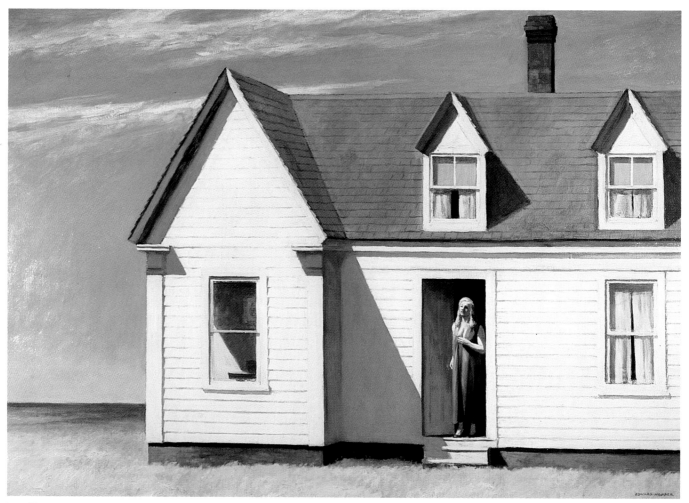

70. *High Noon*. Collection of The Dayton Art Institute, Ohio, Gift of Mr. and Mrs. Anthony Haswell

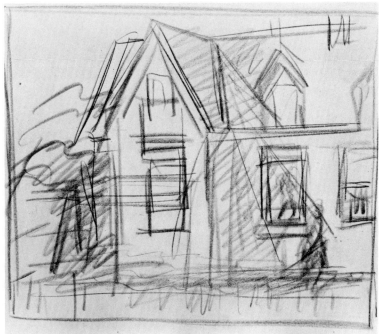

73. *Double-Sided Study for "High Noon"*

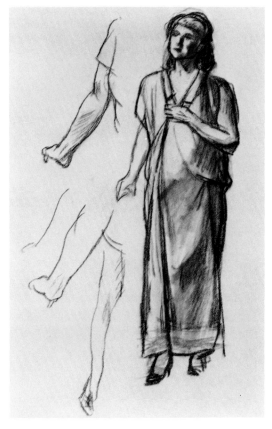

71. *Figure Study for "High Noon"*

*97. *Figure Study for "A Woman in the Sun," with Details of Hand and Feet*

Charcoal on paper, 19 x 12 in.
Executed about 1961

RECORDED: Gail Levin, *Edward Hopper: The Art and The Artist* (1980), p. 298 pl. 428

This drawing and numbers 98, 99, and 100 are studies for *A Woman in the Sun*, 1961 (oil on canvas, 40 x 60 in., Whitney Museum of American Art, New York).

Illus. p. 56

98. *Figure Study for "A Woman in the Sun"*

Charcoal on paper, 14¼ x 10 in.
Executed about 1961

*99. *Sketch of a Bed, Study for "A Woman in the Sun"*

Charcoal on paper, 11 x 15 in.
Executed about 1961

Illus. p. 56

100. *Study for "A Woman in the Sun"*

Conte crayon on paper, 6½ x 9¼ in.
Executed about 1961

*101. *Road and Trees*

Oil on canvas, 34 x 60 in.
Signed (at lower right): EDWARD HOPPER
Painted in 1962

RECORDED: Lloyd Goodrich, *Edward Hopper* (1971), p. 289 illus. in color // Gail Levin, *Edward Hopper: The Art and the Artist* (1980), pp. 39, 50, 222 pl. 304 in color

EXHIBITED: Whitney Museum of American Art, New York, Art Institute of Chicago, Illinois, Detroit Institute of Arts, Michigan, and City Art Museum of St. Louis, Missouri, 1964-65, *Edward Hopper*, p. 66 no. 72

EX COLL.: the artist; to [Frank K.M. Rehn Gallery, New York]; to Mr. and Mrs. John Clancy; to Mr. and Mrs. Daniel W. Dietrich II, Philadelphia, Pennsylvania, in 1967

About this work Gail Levin wrote [*op. cit.*, p. 50]: "Hopper's 1962 *Road and Trees* is remarkable not only for the enchantingly deep, dark woods which the highway passes gracefully by, but for its striking compositional similarity to his much earlier canvas *Canal at Charenton* (oil on canvas, 23¼ x 28¼ in., Whitney Museum of American Art, New York), painted in France in 1907."

Lent by Mr. and Mrs. Daniel W. Dietrich II

Illus. p. 57

*102. *Study for "Road and Trees"*

Charcoal on paper, 5¼ x 9¼ in.
Executed about 1962

Illus. p. 57

103. *Trees and Road*

Charcoal on paper, 10 x 15½ in.
Executed about 1960-62

This drawing may relate to *Road and Trees* (cat. no. 101).

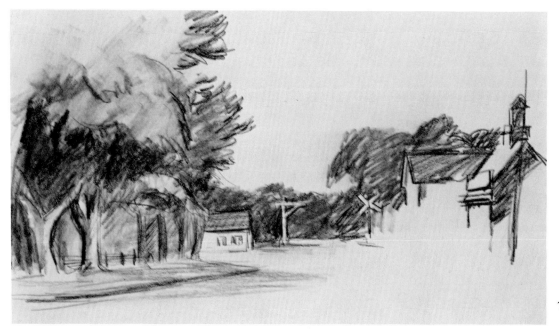

77. *Study for "Portrait of Orleans"*

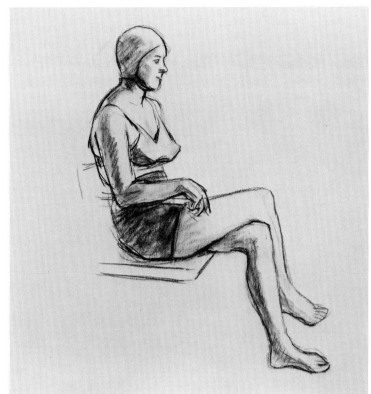

90. Female Figure Study for "Seawatchers"

88. Study for "Seawatchers"

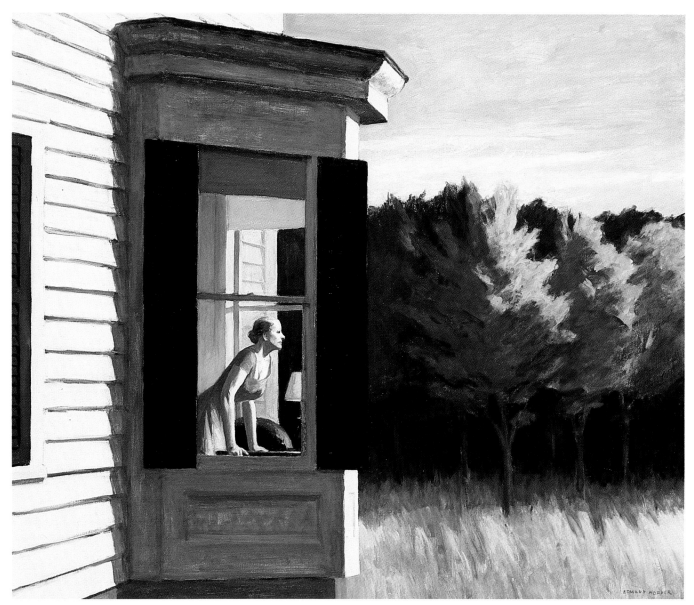

78. *Cape Cod Morning*. Collection of the National Museum of American Art, Smithsonian Institution, Gift of the Sara Roby Foundation

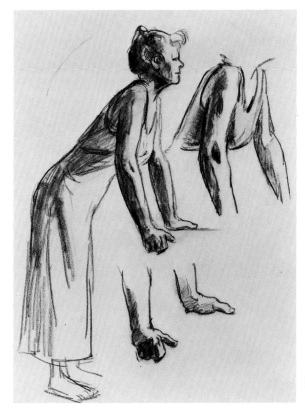

83. *Figure Study for*
 "Cape Cod Morning"

80. *Figure in Window,*
 Study for "Cape Cod Morning"

*104. *Sketch for "Sun in an Empty Room"*

Charcoal on beige paper, 8½ x 11 in.
Inscribed (at lower right): Sketch for "Sun in Empty Room"
Executed about 1963

This drawing is a study for *Sun in an Empty Room*, 1963 (oil on canvas, 28¾ x 39½ in., private collection).

Illus. p. 58

*105. *Study for "Two Comedians"*

Conte crayon on paper, 6¼ x 9½ in.
Executed about 1965

This drawing and number 106 are studies for *Two Comedians*, 1965 (oil on canvas, 29 x 40 in., private collection), which was Hopper's last painting. About that work, Gail Levin wrote [*Edward Hopper: The Art and the Artist* (1980), p. 55]: "Jo ... confirmed that in the tall male comedian and the diminutive female comedian Hopper had represented the two of them. It was intended as a personal statement, a farewell of sorts, for when he showed them gracefully bowing out, he had been ill and would die less than two years later."

Illus. p. 58

106. *Sketch for "Two Comedians"*

Conte on beige paper, 8½ x 11 in.
Executed about 1965

Ex coll.: the artist, until 1967; to his widow Jo Hopper; to Reverend and Mrs. Arthayer R. Sanborn, Nyack, New York, and Florida, until 1988

On the back of this drawing are other sketches for *Two Comedians*.

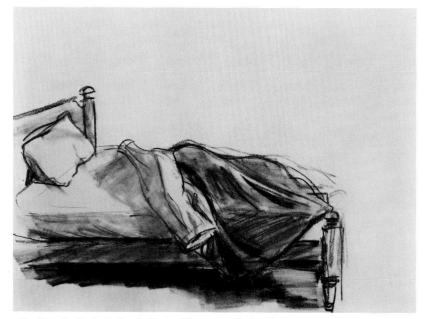

99. *Sketch of a Bed, Study for "A Woman in the Sun"*

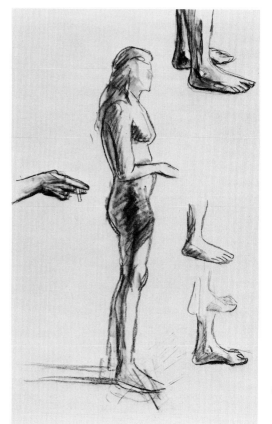

97. *Figure Study for "A Woman in the Sun," with Details of Hand and Feet*

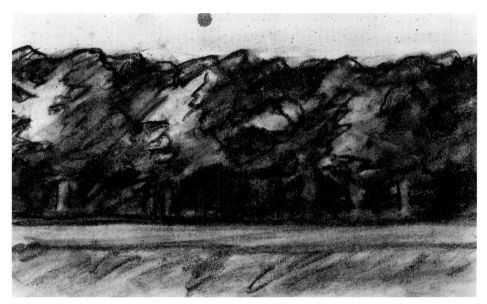

102. *Study for "Road and Trees"*

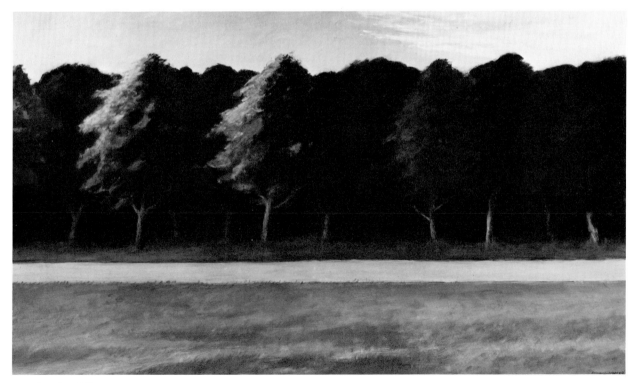

101. *Road and Trees*

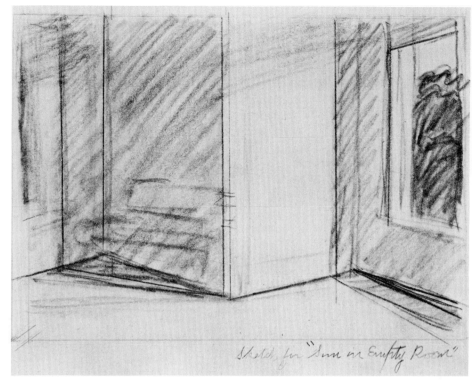

104. *Sketch for "Sun in an Empty Room"*

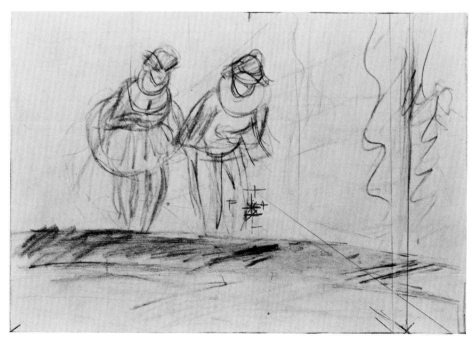

105. *Study for "Two Comedians"*

PHOTO CREDITS